SHAPESHIFTERS, TIME TRAVELLERS AND STORYTELLERS

CANDICE HOPKINS AND KERRY SWANSON

Curatorial Partner: imagineNATIVE Film + Media Arts Festival

Published by the Royal Ontario Museum with the generous support of the Government of Canada through the Department of Canadian Heritage

PREFACE

The Institute for Contemporary Culture (ICC) at the Royal Ontario Museum (ROM) exists to explore contemporary cultural and social issues across many societies and epochs. *Shapeshifters, Time Travellers and Storytellers* was the first original exhibition organized by the ICC for the ROM's new Roloff Beny Gallery, located at the top of the Michael Lee-Chin Crystal, the recently opened addition designed by Studio Daniel Libeskind. The exhibition was open from October 6, 2007, until February 28, 2008.

The exhibition evolved in 2005, when Kelvin Browne, then Managing Director of the ICC, and Christine Lockett, the ROM's Director of Exhibitions, began planning the ROM's Season of Canada program for the Fall of 2007. In collaboration with Kerry Swanson, who worked on behalf of the imagineNATIVE Film + Media Arts Festival, they conceived an original exhibition featuring leading contemporary Aboriginal artists as a key component of the ROM's exhibition schedule. Candice Hopkins was enlisted as co-curator by imagineNATIVE, and in partnership with this organization, the curators selected eight exceptional artists, and five new creations were commissioned especially for *Shapeshifters, Time Travellers and Storytellers*. Alongside these contemporary pieces, the curators displayed some significant but rarely seen artifacts from the ROM's collections to add historical context to the newer works—an important aspect of the ICC's mandate. They also organized the two compelling performances that were presented in conjunction with the exhibition.

On behalf of the ROM, I would like to thank the many organizations and people who collaborated to bring *Shapeshifters, Time Travellers and Storytellers* into existence. First, thanks to the Presenting Sponsor, BMO Financial Group, the lead corporate supporter of this exhibition. We are also very grateful to the Supporting Sponsor, Castlepoint Realty Partners Limited, and to our Curatorial Partner, imagineNATIVE Film + Media Arts Festival. The exhibition and the production of this catalogue were financially assisted by the Government of Canada through the Department of Canadian Heritage.

We are very grateful to our curators Kerry Swanson and Candice Hopkins for assembling and interpreting this relevant and timely exhibition. We sincerely thank all the artists and their representatives who kindly loaned their works. From the ROM, we are indebted to William Thorsell, Director and CEO; Ron Graham, Chair of the ICC; the members of the ICC Board of Directors; Kelvin Browne; Christine Lockett; Jason French; and the Project Team: Cidalia Braga Paul, Laura Comerford, Randy Dreager, Louis Emond, Emilio Genovese, Barb Rice, Zak Rogers, David Sadler, Heidi Sobol, Steven Spencer and Susan Ventura. For the creation of the catalogue, we again thank the curators and artists, as well as the ROM's Art & Archaeology Editorial Board (Peter Kaellgren and Trudy Nicks), Ken Lister, Brian Porter, Glen Ellis, John Rubino, Ginny Morin and Beatriz Alvarez, for their valuable contributions.

Francisco Alvarez
Managing Director, ICC

CONTENTS

INTRODUCTION

In the summer of 2005, the imagineNATIVE Film + Media Arts Festival and the Institute for Contemporary Culture (ICC) at the Royal Ontario Museum (ROM) embarked on a unique collaboration that was to last for over two years. The partnership was born out of a shared desire to engage contemporary Aboriginal artists within the context of the highly anticipated Daniel Libeskind-designed extension to the ROM, the Michael Lee-Chin Crystal, and to create a discourse around the collision between past and present that was to be so conspicuously manifested in the building itself.

As Canada's largest festival showcasing film and video by international Indigenous artists, imagineNATIVE was inspired by the consistently impressive body of installation and multimedia work being shown by contemporary artists, particularly in North America. The festival was keen to present this work as part of its annual event—but on a much larger scale than had previously been undertaken. Kelvin Browne, then Managing Director of the ICC, and Christine Lockett, Director of Exhibitions at the ROM, were excited by the opportunity to reconstitute existing works from the ROM's collection of First Peoples art and artifacts and to engage audiences with the perspectives of contemporary Aboriginal artists, many of whom were able to access the collection for research material and inspiration for new works. The exhibit would also create an opportune moment for engagement with the ROM's recently opened Daphne Cockwell Gallery of Canada: First Peoples, the museum's first permanent gallery in a generation that is dedicated to Aboriginal cultures. This was the starting point for *Shapeshifters, Time Travellers and Storytellers*.

The title itself is a fitting representation of the complex ideas generated by the work of the artists featured in the exhibition: Suvinai Ashoona, Faye HeavyShield, Igloolik Isuma Productions (Zacharias Kunuk, Norman Cohn, Pauloosie Qulitalik and the late Paul Apak Angilirq), Brian Jungen, Cheryl L'Hirondelle, Alan Michelson, Kent Monkman and Nadia Myre. These artists are maverick storytellers whose works challenge linear notions of time, drawing upon and re-enacting both ancient and contemporary stories, often without distinguishing between the two.

When we began the curatorial process for this show, our intention was to explore the ways in which past and present continue to merge and shape each other in contemporary practices, giving new meanings to the ongoing relationships between traditional and contemporary art forms and world views. We were interested in how these artists used traditional

ideas and techniques and how, for some, time travel became a creative strategy. As the new works materialized, specific connections among them began to emerge. One of the most obvious was the idea that history is not linear but cyclical, a reminder of how much the past informs current ideas and conditions. In many works, history had been rewritten and transformed through memory and re-enactment, rendering it neither stable nor static—much like the practice of oral storytelling itself. Stories are the very embodiment of evolution and, like traditional practices, rely on constant change and dynamism to retain their relevance. Together, the works in the exhibition investigated the changing role of the museum as a container for the interpretation of cultures.

Five new site-specific works were created for *Shapeshifters, Time Travellers and Storytellers*, heightening the challenge of mounting a show in a space which was still under construction and which, once finished, would not contain a single vertical wall. Kent Monkman decided early on that he wanted to engage with the First Peoples gallery, specifically responding to the ROM's large collection of Paul Kane works, many of which are prominently exhibited in the gallery's central corridor. Kane's painting *Medicine Mask Dance* (1848–1856), which portrays a constructed "ceremonial dance" of the people of northwest British Columbia, became one of the central sources for Monkman's new painting *Duel After the Masquerade* (2000). The composition is borrowed from the well-known *La Sortie d'un bal masqué*, or *Le duel de Pierrot* (also sometimes referred to as *Duel after a Masked Ball*), painted by Jean-Léon Gérôme between 1857 and 1859. In his rendition, Monkman has replaced the slain figure in Gérôme's painting with Kane. Standing in for Gérôme's costumed assailant, who is being escorted from the scene clad in Native American buckskin, is Monkman's alter ego, Miss Chief Eagle Testickle.

Points of interest for Monkman were the skewing of reality in Kane's studio paintings and the way in which Kane's body of work has been used to develop a mythology around the conquest of North America. Central to this mythology are the exoticism and romanticism of both the Native body and the New World's rugged natural landscape. Kane was deeply engaged with Native culture and its representations, and his goal was to depict an authentic Native subject, but he based his studio paintings on the sketches he'd made during his two-and-a-half-year travels across Canada. As a result, they did not always present events as they had actually occurred. *Medicine Mask Dance*, for example, is set

in what appears to be a pastoral countryside rather than the Pacific Northwest. Kane created works that were often arrestingly beautiful, but the painting style of the period was influenced by the European Romantic movement, and Kane's romanticized and composed studio paintings reflect that influence.

In *Duel After the Masquerade*, Monkman mimics both Kane's and Gérôme's painting styles, choosing as his setting the front garden of the house Kane once owned in Toronto. Still standing at the corner of Church and Wellesley Streets, the building is now in the heart of the city's gay district. The work portrays the aftermath of an epic duel between two painters: the historical titan Kane versus the trickster Miss Chief Eagle Testickle. Kane, visibly stunned, lies defeated in his Indian buckskin costume, supported by a group of white figures wearing traditional West Coast masks. A splatter of red paint, like a bullet wound, drips from his chest. Miss Chief's triumphant farewell glance as she walks away signals the arrival of a new storyteller on the scene.

To create this work, Monkman has travelled back in time to rewrite history, seizing authority over his sexuality, identity and narratives, using humour to remind viewers of the fallibility of accepted notions of truth. Originally conceived as an intervention in the First Peoples gallery that would hang alongside the Paul Kane works, *Duel After the Masquerade* was, instead, displayed next to *Medicine Mask Dance* in the ICC gallery. On the reverse side of the wall was an installation of Miss Chief's regalia, including her *Louis Vuitton Quiver*, *Dreamcatcher Bra*, *High-heeled Moccasins* and *Raccoon Jockstrap*, objects that cheekily blend the contemporary with the traditional. The regalia playfully reconstructs the traditional signifiers of Native culture, while incorporating symbols of mass consumption: the bow bag is constructed from Louis Vuitton designer fabric; the candy-apple-red high heels are adorned with blue beading; and the jockstrap is made from a raccoon-skin hat.

Mohawk artist Alan Michelson also employs the 19th-century landscape-painting tradition—and its primacy in the museum context—as a starting point for his video triptych. A meditative study that reflects upon the past, present and future of three local landscapes, *Of Light After Darkness* considers the story of colonization and the absence of Native perspectives in the accepted version of history. Michelson does not insert the Native body in his landscapes; instead, he contemplates the "absent Indian." [1]

To mirror the traditional museological display of art, Michelson's three video monitors were ornately framed and mounted like paintings on walls that were built specifically for the exhibit, then painted a rich umber and finished with oak moulding. Each 31-minute video, shot in real time, shows the sun as it is beginning to set on a separate horizon. The idyllic sunset in each video is punctured with the signs of settlement and industrialization.

The first video, *Gloom of the Approaching Night: Fort York, Toronto* (2007), was shot at the scene of the War of 1812's Battle of York and the future site of what is now the City of Toronto. People in cars zoom by the heavily industrialized site, oblivious to the ancient stories and hard lessons written on the land. The title speaks to the potential dangers of our alienation from time and the environment. In the second video, *Dying Day Drawing to Its End: Stelco, Hamilton Bay* (2007), the sun is setting over one of the largest factories in Canada, and the yellow lights of the steel plant flicker as they are subtly reflected in the waters of Lake Ontario. In the final video, *Glorious Light of the Setting Sun: Wind Farm, Port Burwell* (2007), the white arms of the windmills at a southwestern Ontario wind farm move almost imperceptibly on the horizon. The quiet paradoxical beauty of these industrialized landscapes, the outcome of colonization and its continued influence in shaping contemporary life, is brought to life in these three videos.

Michelson's decision to shoot his videos at sunset was in response to the twilight/sunset tropes of the Hudson River School of painting and its offshoots, in which sunsets symbolize the melancholy but necessary passing of both Native Americans and undisturbed nature. Accompanying *Of Light After Darkness* was a piece of text attributed to American photographer Edward S. Curtis. Michelson included it as a textual example of the same tropes used by a photographer in whom they were likewise embedded. It reads:

"Alone with my campfire, I gaze about on the completely circling hilltop, crested with countless campfires, around which are gathered the people of a dying race. The gloom of the approaching night wraps itself around me. I feel that the life of these children of nature is the dying day drawing to its end; only off in the West is the glorious light of the setting sun, telling us, perhaps, of light after darkness." [2]

Paul Kane and Curtis shared the same goal, but they used different mediums. Curtis travelled for years to create an

extensive photographic record of Native North American people, eventually compiling a twenty-volume book series first published in 1907. The series continues to represent the best-known portraits of Native people. Unlike Kane's approach, however, Curtis's was not observational; instead, his images were staged, often with the aid of additional costuming or objects with which the photographer travelled. That practice led to inaccuracies that scholars have since identified. In the photograph *Puget Sound baskets* (1912), for instance, Curtis included baskets from the Fraser River and Yakima area. In *Quilcene boy* (1912), the braids worn by the subject are an aberration. [3]

Michelson drew all the installation titles from the Curtis quotation, after he had already conceived the work. As a deliberate reference to the title style often used in 19th-century landscape painting, he then added the name of the location to each. For Michelson, Curtis's references to "a dying race" and "the dying day" are a clear illustration of the mistaken "vanishing Indian" trope that informed his work. Curtis's later reference to "light after darkness" is ambiguously hopeful: it isn't clear whether this "glorious light" will include the dying race in a resurrected form. Michelson has used the quote in an ironic and temporal reversal. The identity of the "dying race"—evidenced in the videos—may have shifted, suggests the artist. Perhaps it isn't the Indians, after all, who have disappeared but, rather, the glorious Western "civilization" that is dying out.

With her delicate sculpture *hours* (2007), Blackfoot artist Faye HeavyShield has re-created one of the most powerful symbols of Western storytelling tradition: a book. Made entirely of white beads and thread and devoid of text, the book was inspired, in part, by HeavyShield's visit to the ROM's collection of Plains beadwork and is an exploration of the traditional practice of beadwork and its process. Beaded in the company of friends and family over several months, the work becomes a document of the stories woven into the object's delicate blank pages. Here, the artist chooses to keep these stories to herself, but the gesture is not ambivalent: the luminescent blank pages of the book suggest limitless possibilities for new narratives to emerge. In the exhibit, *hours* was placed vulnerably on an open plinth without a case. Despite some concern that gallery visitors might be tempted to touch it, HeavyShield insisted that the work should not be deadened by the conventions of static display but viewed, instead, as a piece whose story was active, engaging and participatory.

The fourth new work created for this exhibit, *The Dreamers* (2007), is from an ongoing body of work by Algonquin artist Nadia Myre. In it, Myre constructs an ethereal homage to the male community and its traditional practice of passing down stories and knowledge through the daily activities of hunting and fishing. Three sculptural forms created from thin, free-standing three-metre-long ash poles, red sinew-like material and rocks balance delicately on an organically shaped plinth. As in much of her work, Myre's understanding and appreciation of ancestral practices and protocols are evident. Each pole has been gathered, stripped and carved according to tradition. The installation's natural materials and form exist in dramatic juxtaposition to the sharp angles of the ROM's new space. Reminiscent of traditional harpoons and fishing nets, the work conjures both the tools of the hunt and the hunters themselves. Here, Myre demonstrates that the tools cannot be separated from their users; the users, in turn, cannot be separated from the land that provides both their materials and their purpose.

The Dreamers is a companion piece to an earlier work entitled *Grandmothers' Circle* (2002), in which Myre similarly transforms a group of slender, fragile-looking poles into a talking circle of female elders. The circle references community, storytelling, the making of craft and the cycle of renewal. [4] Myre's minimalist approach in both *Grandmothers' Circle* and *The Dreamers* is her tribute to the traditional Algonquin emphasis on use-value rather than aesthetics. The result: works that transcend time, summoning ancestral stories and memories which endure beyond the artist's and the viewers' experience.

In her new work, *hearing in coyote daze* (2007), Cheryl L'Hirondelle likewise acknowledges the timeless, cyclical connections between humans and their environment. At the exhibit, visitors were invited to perch on a rock-like structure, from which they looked out onto the Toronto cityscape as they listened to a binaural sound recording made at Dreamer's Rock, a sacred Anishnabe crystal-like outcropping on Manitoulin Island. Transposing the sounds of the natural site to the man-made Michael Lee-Chin Crystal, L'Hirondelle asked viewers to pause to remember the Earth—its stories and histories—quietly breathing below this celebrated museum and everything contained within it. Her work captures the present moment of nature's fragility and transition even as it transports us to a quieter time and place. Invoking Coyote, the trickster at the centre of many Indigenous stories, the artist also reminds us that things are not always as they appear:

despite the peaceful sounds of nature, the tranquility at Dreamer's Rock is today disrupted by the relentless hum of a major highway that passes nearby.

As with Faye HeavyShield's work, the making of this piece represented the input and assistance of many people. One can gain permission to visit Dreamer's Rock only by following the proper protocols, and that takes trust and time, which L'Hirondelle earned over several visits to the island. The sounds recorded in *hearing in coyote daze* thus reflect the efforts of not just one artist but an entire community.

In addition to the new pieces created for the show, several existing works were selected to further illuminate the concepts presented in the exhibition. In *Cetology* (2002), from Brian Jungen's series of whale sculptures, the artist has transformed a symbol of global mass production and aesthetic banality—the plastic lawn chair—into the skeleton of an endangered bowhead whale, powerfully evoking the link between industrial production and mass extinction. The work is a shapeshifter: a rare and noble creature, among the Earth's oldest living species, has been created from something culturally ubiquitous and spiritless. Suspended from the gallery's spine, *Cetology*, which is more than twelve metres long, provided a crucial physical anchor to the show, commanding an undeniable authority over the space through its sheer size. At the same time, the piece—hanging in the balance, as it were—telegraphed a sense of vulnerability and loss, forging a natural connection to the exhibit's other installations and themes. Its unmistakable invocation of the vanished dinosaurs whose remnants are such a large and storied component of the ROM's collection (and are now displayed in the space beneath the ICC's Roloff Beny Gallery) reinforced that message, as it implicitly raised the spectre of the fate of Western cultures—and even the human race.

Jungen's work reminds us of the ongoing and contradictory human desire to retell, remember and romanticize the stories and creatures of the past, even as we oversee the destruction of the environment and the extinction of species in the present. (Today, the plastic material from which this sculpture was made seems destined to remain on the planet long after the giant mammal it represents has disappeared.) By not entirely existing as one thing or the other, the sculpture destabilizes the economic and cultural values that attach to both consumer and object: ontological stability is prevented

by "the complexity of economic cycles and the dilemmas of the post-colonial condition." [5] With this in mind, it is perhaps not the tension created by bringing together two dissimilar objects and materials that is important but, rather, the very potential to transform the relationships between them and what they stand for.

Igoolik Isuma Productions, Inc., founded in 1988 by Zacharias Kunuk, Norman Cohn, Paul Apak Angilirq and Pauloosie Qulitalik as the first independent Inuit production company, continues to forge new ground in storytelling traditions. We included the groundbreaking thirteen-part dramatic television series *Nunavut* (*Our Land*, 1994–1995), which documents the lives of five fictional Igloolik families in 1945, to illustrate how modern technology is being used to pass on oral traditions and cultural knowledge within contemporary Indigenous communities.

Isuma, which means "to think" in Inuktitut, embodies the ethos of keeping ancestral knowledge alive and providing an alternative narrative to the stories offered on television and in movies in the Arctic, particularly for the young MTV generation. The opportunity for re-enactment made possible by video technology allows both the storytellers and their audiences to inhabit the time period of their choosing. In the 1930s and 1940s, missionaries had begun travelling to the North to introduce Christianity and begin the process of cultural assimilation among Inuit. This assimilation took place on several levels: language, through the introduction of English; subjectivity, with community members assigned new names; and place, as families were asked to gather in centralized locations for school and church services. Eventually, they were made to forgo their nomadic life for permanent settlements, and *Nunavut*, directed by Zacharias Kunuk, documents that process. The series' last episode—filmed in black and white—shows Inuit awkwardly trying to incorporate the new holiday of Christmas into their lives.

Through its body of work, Isuma appropriates modern technology to dramatize traditional stories and legends, to re-create historical events from an Inuit perspective, to tell the stories of contemporary Inuit and to document traditional practices for future generations. Set in the Arctic, *Nunavut* shifts between past and present, fiction and reality, documentary and drama. The actors, like traditional storytellers, take on the identities of the people they are portraying. Inuit believe that people who have passed find their way into the present through the living, and Inuit children are often given the

name of a recently deceased person. Time is understood to be cyclical, and there is an intrinsic cultural recognition of how much the past plays an active role in understanding the present.

The intricately rendered landscapes of Suvinai Ashoona, an Inuk from Cape Dorset, follow this tradition. In Ashoona's drawings, the details of the Northern landscape in all its minutiae take over the entirety of the picture plane. Through her drawing process, the landscape becomes increasingly fictive, imagined and hypothetical. Like the generations of Inuit drawings that preceded them, Ashoona's drawings show more than one instant in time and multiple perspectives on a single plane. The emphasis is not on the division between different moments but on their connections and continuity. Her work illustrates how art traditions and practices are themselves a continual process of renewal and evolution.

Inuit drawings are widely recognized as "traditional" art, even though Inuit began working with paper only in the early 20th century. While the practice has remained largely static in form over the decades, Ashoona offers a contemporary interpretation. Importantly, her drawings present art as a way of understanding the environment, of interpreting the meaning in the everyday. Like the pencil drawings of her predecessors, spatial perspective and proportionality exist according to their relativity to daily life, and there is no separation between the "real" and the "imaginary." Ashoona subverts her own role as storyteller, maintaining a distance through a bird's-eye point of view.

In addition to the new and existing works selected for the exhibition, we felt that it was important to engage with objects from the ROM's collection, using this as an opportunity to demonstrate their continued ability to inform contemporary practices. The two objects and the series of drawings selected suggest nuanced parallels to the existing works, without reverting to simple binaries between past and present and contemporary and traditional practices. By developing deliberate spatial relationships between the works and creating space for dialogue, the exhibit encouraged visitors to consider the relationships between the contemporary objects and those from the collection.

The mammoth tusk (Pleistocene epoch, 1.8 million to 10,000 years ago) was unearthed by miners in the Arctic in the late 1800s and given to Inuk artist Joe Kakarook, who carved the poignant scenes of Inuit life on its surface. Of particular interest was what he chose to represent. Depicted on the tusk is a time of extreme cultural transition in the North, from

nomadic to settlement life. In thin, dark lines, dogsleds and the modest wooden houses of early settlement life are drawn on the same plane as renderings of the coastline and hunting scenes. The tusk was found in a Victorian curio shop in the United States and later purchased by the ROM. It has seldom been displayed, but we were immediately struck by its connections to the work in the exhibit, particularly with Isuma's re-enactments of early-20th-century life—which also focus on the transition to settlement life—and with Brian Jungen's *Cetology*, which, like the mammoth, encourages us to consider the fragile nature of existence.

Moments of colonial contact are often seen as a dividing line between past and present and continue to be used as the point at which "history" begins. For this reason, we chose to include a selection of Inuit drawings that were commissioned by documentary filmmaker Robert Flaherty. Filmmaking has had a long association with the Arctic, beginning with Flaherty's 1922 film *Nanook of the North*, widely considered the first feature-length documentary film ever made. Preceding *Nanook of the North* by more than a decade, however, was Flaherty's first attempt to film in the North during a trip funded by Sir William Mackenzie in 1913–1914. Filming in this climate was not an easy feat. Not only was the equipment large and cumbersome, but the cold posed its own obstacles, not the least of which was finding a way of developing film in an environment where any available water was already frozen. A fire that started when Flaherty was developing a film reel destroyed his only record of the events from that period.

One of the few visual markers that remain is the series of pencil drawings that Flaherty had commissioned from his Inuit counterparts, intending them to be used as bookplates. The drawings, now in the ROM collection, are early incarnations of what has become an established Inuit art tradition of drawing and printmaking, rendered anew by Suvinai Ashoona. Many show everyday life in the North: hunting, travel by dogsled, game playing at the foot of giant supply ships. But one is a rendering of Flaherty with a tripod, surrounded by his assistants, as he films Inuit building a life-sized igloo as a prop for one of the scenes. In this single drawing, the documentary process is reversed, with the filmmaker now represented by the very subjects he was capturing on film. The drawing serves as an early example of Aboriginal artists taking authority and ownership over their stories.

The final object—a small pouch woven from bast fibre of a style made in the Great Lakes region from the 18th century to the early 20th century—is a different example of colonial contact. In this case, it demonstrates how Native aesthetics and world views were incorporated into new art practices that utilized Western materials. The turtle design woven into the pouch might be read as a reference to the creation stories of Turtle Island; it might also be in reference to a family/clan Dodem, or symbol. As in the work of Faye HeavyShield, Nadia Myre and Cheryl L'Hirondelle, the functional purpose of the bag is a reminder of how art, everyday life and storytelling are intrinsically linked. When we first viewed the pouch, we thought it was connected to the wampum belt it contained. However, the specific details as to who made the pouch or why remain unknown. Our interest in the object was in its reference to the Great Lakes region and to Toronto, both as a traditional meeting point for many different groups of Native North Americans and as the site of historic agreements and treaties, signified by the wampum belt. This object is a poignant reminder of how these objects, sitting quietly in darkened storage containers or encased in glass, hold on to their stories. We hope this exhibition will have served as a starting point for other narratives to emerge from continued engagement between these objects and contemporary Aboriginal artists.

We thank the artists, the Institute for Contemporary Culture and the Royal Ontario Museum for their generous and collaborative approach to this exhibit. The ROM's Daniel Libeskind-designed wing is a powerful metaphor not only for the evolution of the museum but for how the past continues to inform and shape the present in ways that open new avenues for discourse and interpretation. In this inaugural original exhibit for the Roloff Beny Gallery, we seized the opportunity to open a dialogue among living Aboriginal artists, the Institute for Contemporary Culture, whose mandate is to reflect contemporary perspectives, and the Royal Ontario Museum, whose collection of First Peoples work holds many possibilities for continued exploration and interpretation. We hope it marked the beginning of what will become a long and fascinating conversation.

NOTES

1 Gerald McMaster, "Alan Michelson: Revealing the Absent Indian," in *New Tribe: New York: The Urban Vision Quest,* ed. Gerald McMaster (Washington, D.C.: Smithsonian National Museum of the American Indian, 2005).

2 T. C. McLuhan, "Curtis: His Life," in *Portraits from North American Indian Life,* Edward S. Curtis (New York: A&W Visual Library, 1972), viii.

3 Mick Gidley, *Edward S. Curtis and the North American Indian, Incorporated* (Cambridge: Cambridge University Press, 1998), 287.

4 Rhonda Meier, "Bearing It," in *Nadia Myre: Cont[r]act* (Montreal: Dark Horse Productions, 2004).

5 Cuauhtémoc Medina in *Brian Jungen* (Vancouver: Vancouver Art Gallery and Douglas & McIntyre, 2005), 33.

WORKS

SUVINAI ASHOONA

Suvinai is aware of her role as a chronicler, but she also sees herself "as an intermediary between time and place. She has said that these images are often transmitted through her pen onto the paper so that it seems as if she is releasing the drawing from the paper."

– Melanie Medd on Suvinai Ashoona, from *Time Interrupted* (Feheley Fine Arts, Toronto, Ontario, 2006)

Suvinai Ashoona

1 *Composition (Opening the Tent Door)*, 2005–2006
 Ink on paper
 38 x 28 cm
 © Dorset Fine Arts/Courtesy Feheley Fine Arts

2 *Composition (Tent Surrounded by Rocks)*, 2004–2005
 Ink on paper
 66 x 51 cm
 © Dorset Fine Arts/Courtesy Feheley Fine Arts

3 *Composition (Camp Scene)*, 2001–2002
 Ink on paper
 51 x 66 cm
 © Dorset Fine Arts/Courtesy Feheley Fine Arts

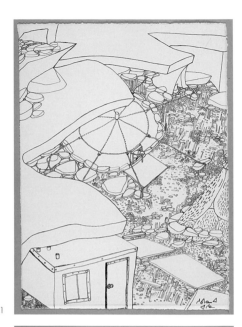

1

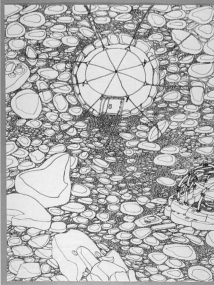

2

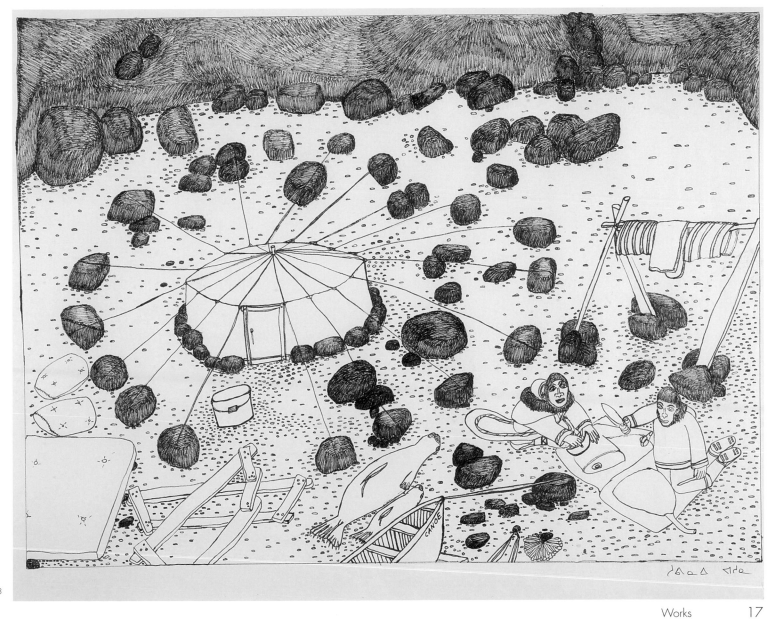

3

FAYE HEAVYSHIELD

Last year's visit to the ROM collections was inspiring, seeing the work done by Blood people all those years ago. It led me to think about the distinction of their practice, how function was not separated from art, how art was everyday. The time spent beading, as suggested by the title of my work, is a tie to this ordinariness, as is the scale—which is reminiscent of a small missal or diary. My work *hours* is not proffering anything in the way of historical reference— except for my own touch.

– Statement by the artist

Faye HeavyShield
hours, 2007
Beads, fabric
22 x 32 cm

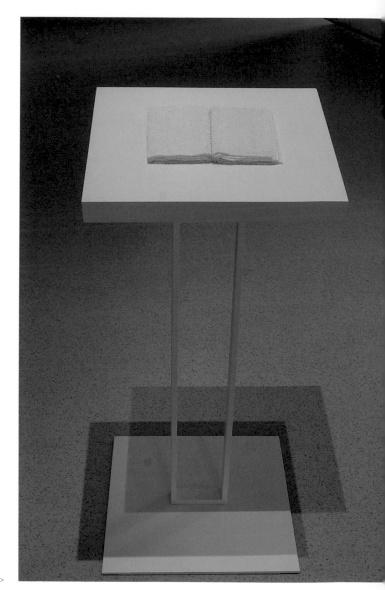

Installation View >

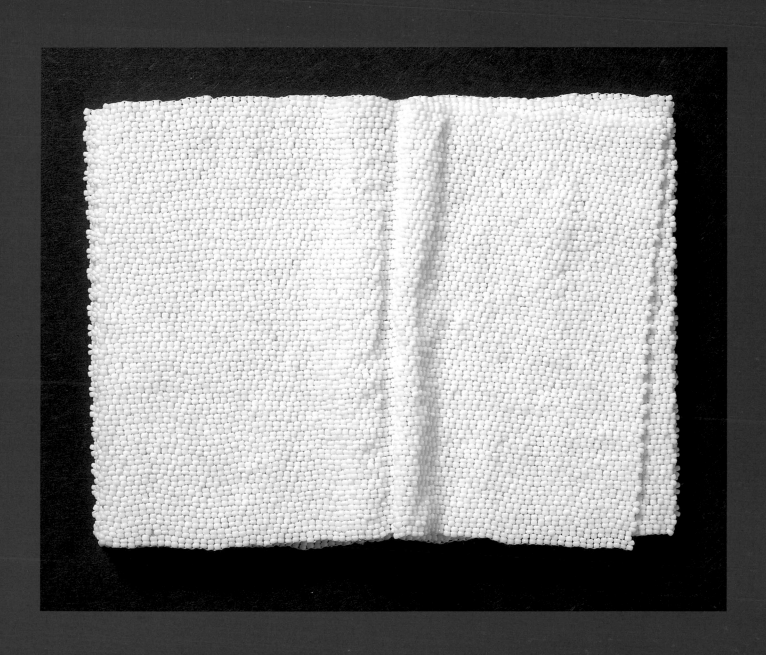

ISUMA PRODUCTIONS

Norman Cohn

Conventional filmmaking has a hierarchy just like the military. Every relationship is vertical. Every individual knows exactly who is one notch ahead of him or her or one notch below. Inuit aren't like that. Nobody ever salutes. The Inuit process is very horizontal. We made our film in an Inuit way, through consensus and collaboration.

Zacharias Kunuk

When we worked for the Inuit Broadcasting Corporation, we would visit elders and they would tell us terrific stories, but once you got through at the editing table, you had no footage of them left. Our goal became to re-create the past. When we started, we had no script. We told the actors what we wanted, and they just did it.

– Statements by the artists

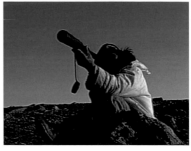

Igloolik Isuma Productions

Norman Cohn, Zacharias Kunuk, Paul Apak Angilirq and Pauloosie Qulitalik

Nunavut (Our Land), 1995

Thirteen-part video series, 30 minutes each

Episode 1: *Qimuksiq (Dogteam)*

Episode 2: *Avaja (Avaja)*

Episode 3: *Qarmaq (Stone House)*

Episode 4: *Tugaliaq (Ice Blocks)*

Episode 5: *Angiraq (Home)*

Episode 6: *Auriaq (Stalking)*

Episode 7: *Qulangisi (Seal Pups)*

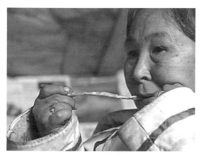

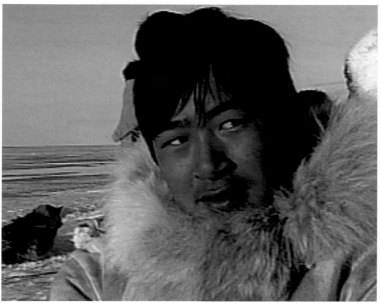

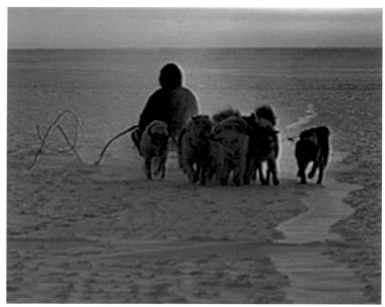

BRIAN JUNGEN

There are plenty of historic examples in the artwork of First Nations cultures where European products were modified and used for their aesthetic qualities, thereby changing the intended use-value of these products. This type of exchange accrued as contact with European traders spread across the continent, but I am curious to know why this component of history is not "revived" in today's carving and regalia. It is accepted that the institutionalization of First Nations "artifacts" by the anthropologists in the 19th and early 20th centuries had the effect of dictating what was to be constituted as authentic.

– Brian Jungen, in conversation with Simon Starling.
Excerpt from *Brian Jungen* (Vancouver: Vancouver Art Gallery and Douglas & McIntyre, 2005)

Brian Jungen
Cetology, 2002
Plastic chairs
162 x 169 x 1,260 cm
Collection of the Vancouver Art Gallery; Purchased with the financial support of the Canada Council for the Arts Acquisition Assistance Program and the Vancouver Art Gallery Acquisition Fund, VAG 2003.8 a-z

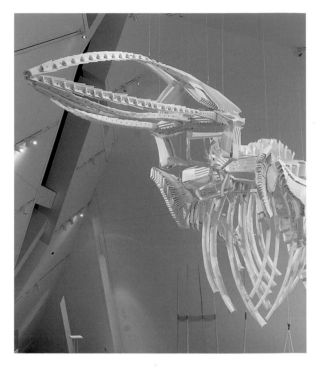

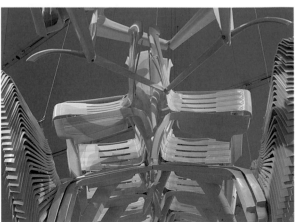

Installation Views

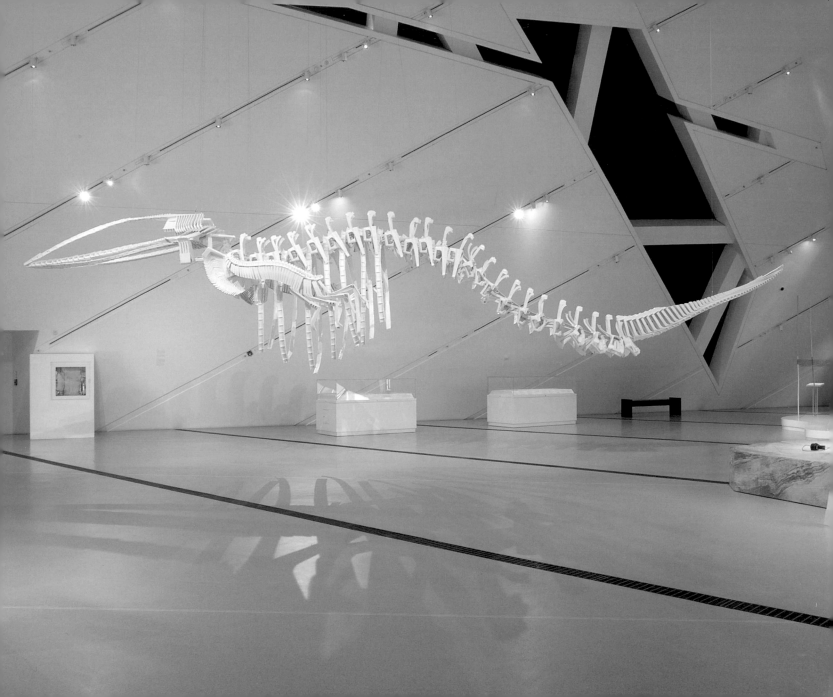

CHERYL L'HIRONDELLE

My initial thoughts for this work were to transpose the sound of a natural crystal outcropping—Dreamer's Rock on Manitoulin Island—onto the city landscape and inside the ROM's Crystal as a reminder of how the natural terrain had once been. While making this piece, I inadvertently snuck up on a coyote (the trickster) in a field and decided to include additional sounds farther off the beaten track that would best approximate what that place may have sounded like. In a performative manner, my process was to become the recorder and to lie, sit and wait, as though fasting or praying.

– Statement by the artist

Cheryl L'Hirondelle

hearing in coyote daze, 2007
Binaural sound installation, 8 minutes

Installation View >

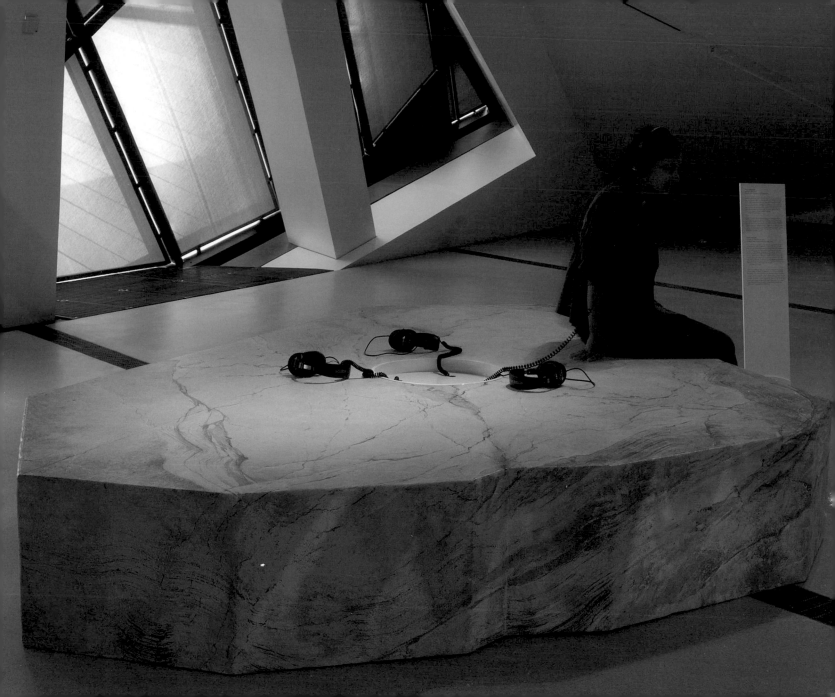

ALAN MICHELSON

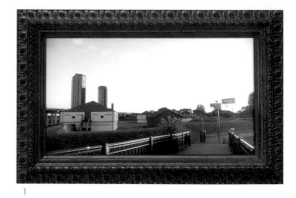

1

"Alone with my campfire, I gaze about on the completely circling hilltop, crested with countless campfires, around which are gathered the people of a dying race. The gloom of the approaching night wraps itself around me. I feel that the life of these children of nature is the dying day drawing to its end; only off in the West is the glorious light of the setting sun, telling us, perhaps, of light after darkness."

– Excerpt selected by the artist from *Portraits from North American Indian Life*, 1972, by Edward S. Curtis

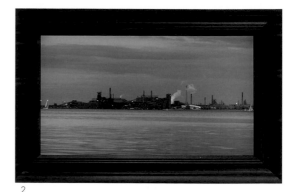

2

Alan Michelson

Of Light After Darkness, 2007

Video installation with gilded frames

1 *Gloom of the Approaching Night: Fort York, Toronto*, 2007; 31 minutes

2 *Dying Day Drawing to Its End: Stelco, Hamilton Bay*, 2007; 31 minutes

3 *Glorious Light of the Setting Sun: Wind Farm, Port Burwell*, 2007; 31 minutes

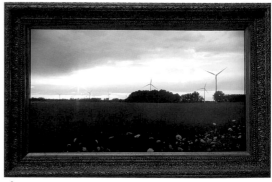

3

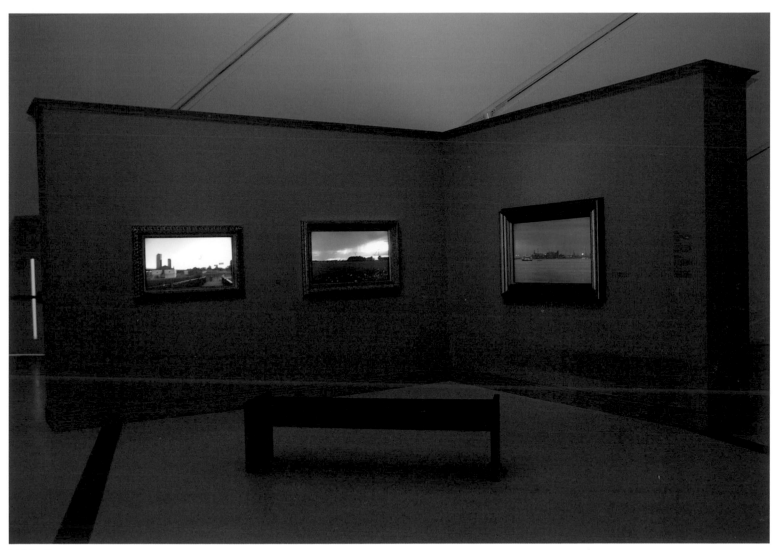

Installation View

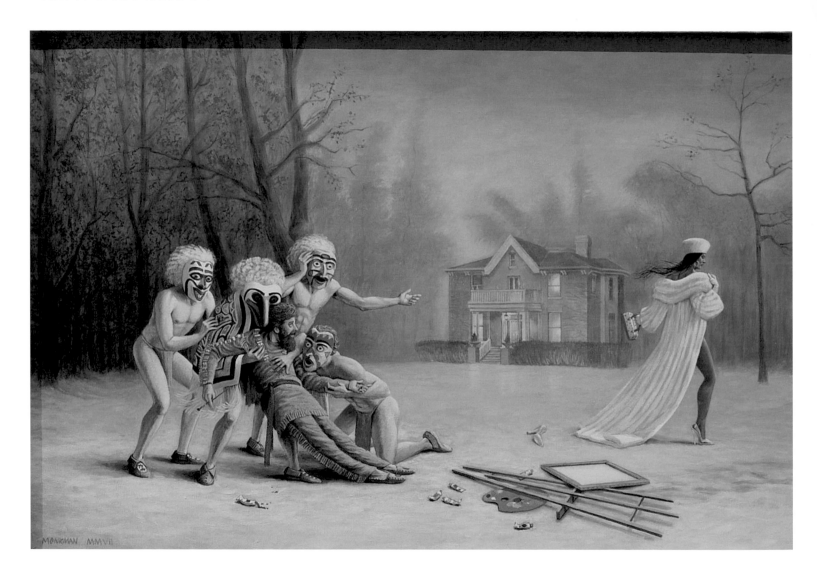

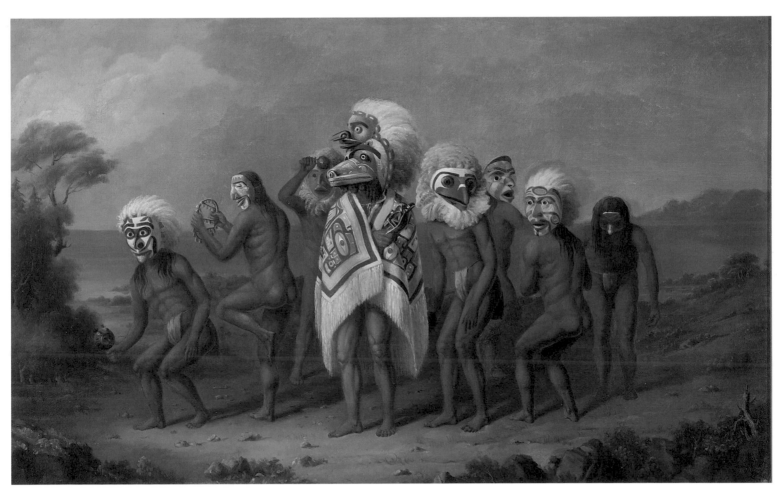

< Facing Page:

Kent Monkman

Duel After the Masquerade, 2007

Acrylic on canvas

51 x 76 cm

Paul Kane

Medicine Mask Dance, 1848–1856

Oil on canvas

57 x 85.5 cm

912.1.92

KENT MONKMAN

I had grown accustomed to seeing so many white men in and around our village. One of these gentlemen, Paul Kane, a struggling artist, lived in a brick home near the centre of our village at Church and Wellesley. He was a painter of "Indians," and I also being a painter, and an exquisite specimen of the Red Race, prevailed upon him numerous times to acquaint himself with my attributes as a model. Being rather conspicuous in stature and extremely forward in style of dress, I was certain that I would capture his attentions and become the subject of one of his now famous portraits. Unfortunately, I was to suffer much humiliation when he publicly declined to create a likeness of me. He claimed that my "authenticity" was questionable, as was evidenced by the "contamination" of European influence in my style of dress. He much preferred my buckskinned brethren who lived far north in the wilderness, who were, in his mind, unsullied examples of the Red Race and therefore more bona fide subjects for his paintings. This mortification was too much for my proud spirit to bear, knowing that these humble trappers and hunters, while capable of attaining a certain elegance in their hunting and fishing attire, cared little as I did for the latest in fashion from Paris and Milan. To save face, it was necessary to challenge him to a duel—a painters' duel—the outcome of which is the subject of one of my many paintings.

– Statement by the artist's alter ego, Miss Chief Eagle Testickle

PAUL KANE

"On my return to Canada from the continent of Europe, where I had passed nearly four years in studying my profession as a painter, I determined to devote whatever talent and proficiency I possessed to the painting of a series of pictures illustrative of the North American Indians and scenery. The subject was one in which I had felt a deep interest in my boyhood. I had been accustomed to seeing hundreds of Indians about my native village, then Little York, muddy and dirty, just struggling into existence, now the city of Toronto, bursting forth in all its energy and commercial strength. But the face of the red man is no longer seen. All traces of his footsteps are fast being obliterated from his once favourite haunts, and those who seek to study his native manners and customs must travel far through the pathless forest to find them."

— Excerpt selected by Kent Monkman from *Wanderings of an Artist Among the Indians*
of North America: From Canada to Vancouver's Island and Oregon
Through the Hudson's Bay Company's Territory and Back Again, 1859

KENT MONKMAN

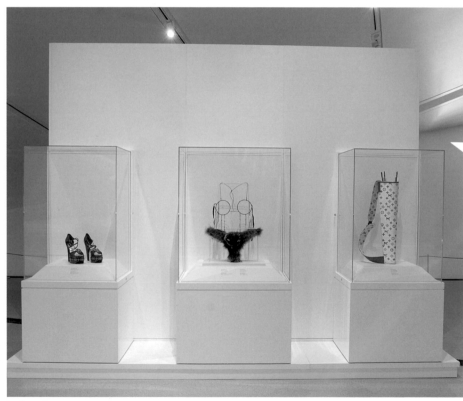

Installation View

Kent Monkman

1 *High-heeled Moccasins,* 2007
 Mixed media

2 *Dreamcatcher Bra,* 2005
 Mixed media

3 *Raccoon Jockstrap,* 2005
 Mixed media

4 *Louis Vuitton Quiver,* 2007
 Mixed media

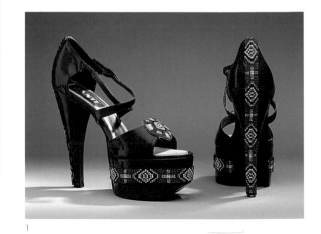

1

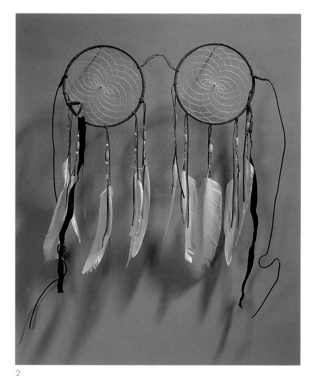

2

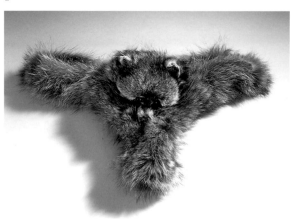

3

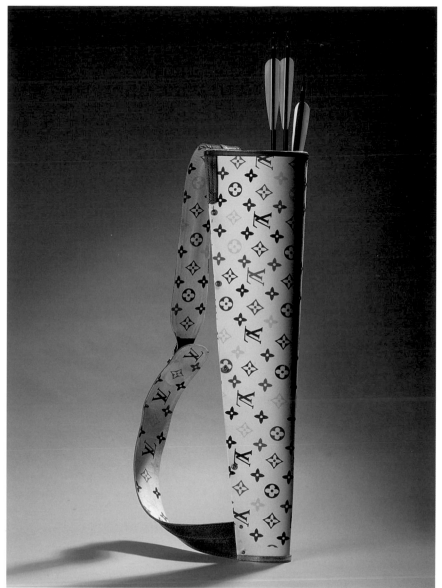

4

NADIA MYRE

The Dreamers, a sculptural installation handcrafted from ash wood, is a poetic reference to hunting tools. Inspired by harpoons, fishing nets, snares and the structural archetype of the spear, this piece speaks of ancestral ways and primordial dreams. The title suggests the complexity of dreaming as a recollection of the past versus the prosperity of a future. Traditionally, fabrication of these tools—like the snowshoe—was part of a larger process essential for survival. However, as these tools are imagined, the "dream" becomes one of memory and loss.

<div align="right">

– Statement by the artist

</div>

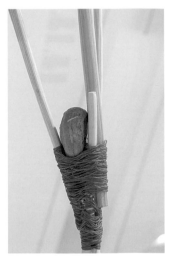

Nadia Myre

The Dreamers, 2007

Ash poles, string, wooden base

3 x 2 x 5 m

© CARCC 2008

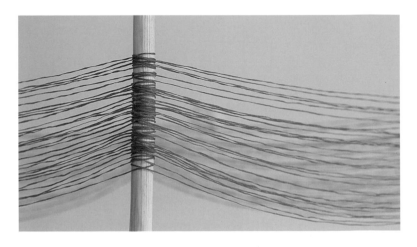

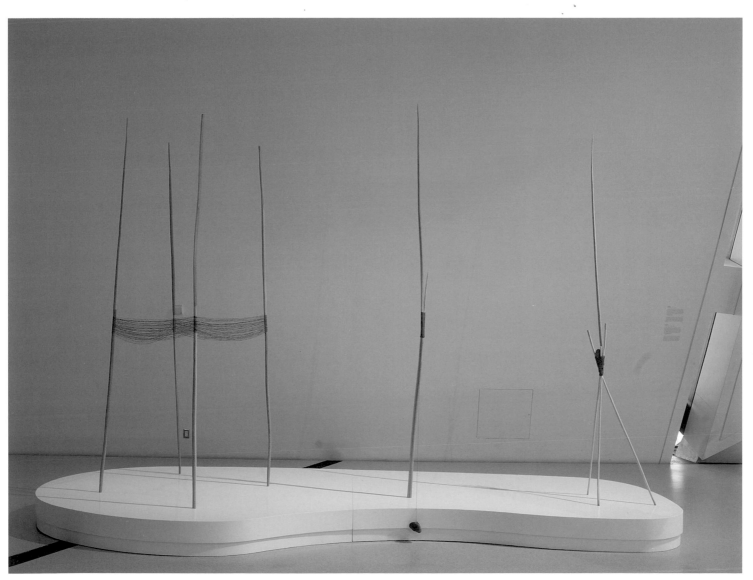

Installation View

ROM ARTIFACTS

Mammoth Tusk

In a conflation of different time periods, a Yupik man known by the English name Joe Kakarook carved this representation of Inuit everyday life during the winter of 1899 on a mammoth tusk that dates back to the Pleistocene epoch (1.8 million to 10,000 years ago). The carving documents the rapid transition from itinerancy, which continues to influence Inuit culture today, to settlement life.

Mammoth tusk, Pleistocene epoch; carved in late 19th century

Attributed to Joe Kakarook

Bering Strait Eskimo culture; Alaska, U.S.A.

13.2 x 147.5 cm

917.11

Gift of Sir Edmund Osler

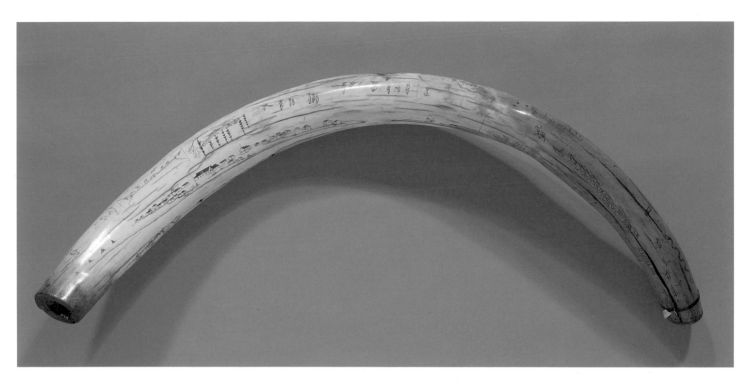

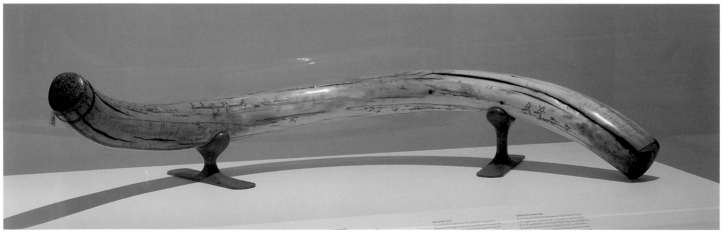

Mammoth Tusk

Défense de mammouth

Drawings

These drawings were made for Robert Flaherty, the American director of the 1922 film *Nanook of the North*, during his 1913–1914 expedition to the Arctic. They were later compiled into a self-published book. Funded by Sir William Mackenzie, Flaherty made his initial attempts at filming in the Arctic during this period. In some instances, the Inuit drawings provide a rare reversal of perspective, wherein the subjects of Flaherty's film made him—and the scenes that he was capturing—the focus of their own representations.

Prints, 1913–1914

Enooesweetok (dates unknown)

Inuit; Sikosuilarmiut (now called Kingarmiut)

Amadjuak Bay, Nunavut, Canada

1 *Ivik Keinek/Walrus Hunting*
 Ink on paper
 6.5 x 10 cm
 960.76.6
 Robert J. Flaherty Collection; Gift of Mrs. Robert Flaherty

2 *Ivik Keinek Okeeyuitme/Walrus Hunting in Winter*
 Ink on paper
 6.5 x 10 cm
 960.76.7
 Robert J. Flaherty Collection; Gift of Mrs. Robert Flaherty

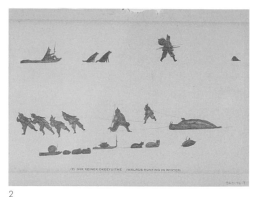

1

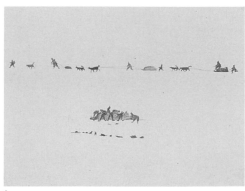

2

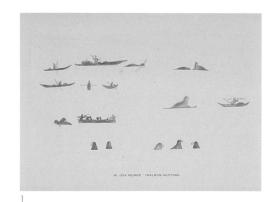

3

4

5

6

7

3 *Innuit Numuk Tutoot/Esquimaux packing in Summer*
 Ink on paper
 6.5 x 10 cm
 960.76.17.A
 Robert J. Flaherty Collection; Gift of Mrs. Robert Flaherty

4 *Innuit Pektockseauk/Esquimaux Playing a Game*
 Ink on paper
 6.5 x 10 cm
 960.76.18
 Robert J. Flaherty Collection; Gift of Mrs. Robert Flaherty

5 *Ungnau Omiak Kyakloo/Woman's Boat and Kayak*
 Ink on paper
 6.5 x 10 cm
 953.110.1.C
 Gift of Miss Lorna Durst

6 Untitled drawing
 Possibly 1913–1914
 Attributed to Enooesweetok (dates unknown)
 Inuit; Sikosuilarmiut (now called Kingarmiut)
 Amadjuak Bay, Nunavut, Canada
 Pencil on paper
 5 x 8.5 cm
 960.76.26
 Robert J. Flaherty Collection; Gift of Mrs. Robert Flaherty

8

Drawings
Possibly 1915–1916
Attributed to Weetaltuk (dates unknown)
Inuit; Qikirtamiut
Belcher Islands, Nunavut, Canada
Pencil on paper
7 x 10 cm
Robert J. Flaherty Collection; Gift of Mrs. Robert Flaherty

7 *Baseball game on the ice—New Year's Day* (detail)
 960.76.42.P

8 *Flaherty filming the construction of an igloo* (detail)
 960.76.42.R

Works 39

Woven Bag

Although its maker and date are unknown, this modest
woven bag is associated with a wampum belt, a sacred
object that embodies the practices of storytelling, art,
trade and treaty making. The object's origin is the Great
Lakes region, and it is representative of the coming
together of many different cultures at a time when
Toronto and the surrounding area were establishing
roots as a meeting ground.

Woven bag, late 18th century

Maker unknown; Central Great Lakes region

Bast fibre in natural, black and grey-green colour; red woollen yarn

11.5 x 16 cm

911.3.130.A

Oronhyatekha Collection; Gift of the Independent Order of Foresters

PERFORMANCES

The following two performances were presented at the Royal Ontario Museum as part of the 2007 imagineNATIVE Film + Media Arts Festival, in conjunction with the *Shapeshifters, Time Travellers and Storytellers* exhibition.

PETER MORIN

October 5, 2007
Two stories about *A Return to the Place Where God Outstretched His Hand*

Sponsored by the Urban Shaman Gallery, Winnipeg, Manitoba

1. A young Tahltan person gets sent to residential school. Has his hair cut. Isn't allowed to speak his language. Gets hit for being Tahltan.
 The spirit tells the Tahltan boy to practise the ceremonies in secret, when everyone is asleep. So, in the night, the Tahltan boy practises the ceremonies. He practises with purpose, as is the way he was taught. He was taught to carefully consider his words and actions. This is his way to keep his spirit alive and to keep his connection to his home territory. It is his secret. It is his heartbeat.

2. A young Tahltan person makes a return to the Tahltan boy's story. This is a ceremony of connecting to the stories, of connecting to the makers of culture.

How Tsesk'iya Cho *got the Sun, Moon and Daylight*
– interpreted from the words of Tahltan elder Grandma Eva

Long time ago,
there was too much darkness;
man and wife
and daughter.

When the time came, daughter became a woman.
Too much darkness, man and wife took her to a cave far from
 the village.
They put her in that cave *where god outstretched his hands*,
and they put a moose skin over her head.

They made her stay in the cave.
Only women can come to her.
The women brought sewing for her to do.

Too much darkness, man and wife wanted to keep her good
so she could marry some nice good man.
They made little place for her to stay
behind their own house.

She never went anywhere.
She was real good
and never fooled around with anyone.

Too much darkness, man and wife watched careful;
even watch what she drinks.

Tsesk'iya Cho knows that the father keeps Sun, Moon and
 Daylight.
He thinks, "How am I going to get light for the world?"

One day, he makes himself as small as a speck of dirt.
He puts himself into her cup of water, the cup that her mother
 brings her to drink.
The daughter says, "Throw that water away. There's a speck of
 dirt in it."
So they spill the water, and *Tsesk'iya Cho* jump out.

He watched that girl.
Just as she was ready to drink again,
he jumped to her lips as just a small speck,
and she swallowed him.

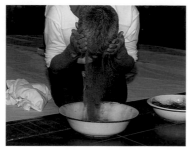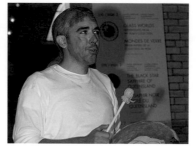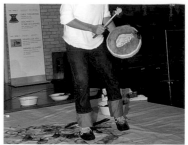

After a while, that daughter says,
"Mother, I don't know why something is growing in my womb."

The mother says, "Maybe you're not careful."

But the girl says, "How come you never see anyone around here?"

So they wait.

And she has a little baby boy.

The father says, "Wait until he can talk, then we will learn how he got here."

So they wait.

That boy grows fast.

One day, he can walk around.
He sees the Moon on the wall.
He starts to cry for it.
He cries, cries and cries.
He won't stop crying for that Moon.

He cries until his grandmother says,
"Oh, why don't you give him the Moon to play with? He won't hurt it. Then you can put it back. Don't be so stingy."

He plays with it for a little while.

Then he says, "Grandpa, give me the Sun to play with."

Grandma says, "Give him the Sun. Maybe he will get a headache and get sick from that crying."

He plays with that.

Then he asks for the Daylight. "Give me the Daylight to play with, Grandpa."

Grandpa says, "No."

But he gives it to him.

When that boy got Daylight,
he grab the Moon
and the Sun,

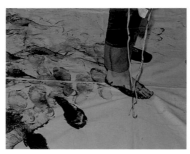

and quick as anything,
he turn into *Tsesk'iya Cho*
and flies up through the smoke hole in the roof.

Tsesk'iya Cho go, "CAW!" and *Tsesk'iya Cho* is gone.

When *Tsesk'iya Cho* gets outside, he throws the Moon into the sky,
and there's a great loud noise in the world.

CRASH!

Then he throws the Sun up in the air,
and there is another really loud noise.

CRASH!

The animals get really scared.
They start running.

The fish go to the seas.
The goats and sheep ran to the mountains.
The beaver ran to the rivers.
All the animals ran.

Marten ran up a tree.
He see *Tsesk'iya Cho*, and he see he's got Daylight.
He shouts, "Daylight coming! Daylight coming!"

Grizzly was under that tree.
He was scared and in such a hurry to run
that he put his moccasins on the wrong feet.

That's why if you look at Grizzly tracks,
you see he got his toes on the wrong side of feet.

2.

I go outside to collect long walks and ravens.

The walks are usually cold,
and the ravens usually need coercing.

It often takes many hours to get the collected ravens home.
And once they are there with me, in the apartment, we watch TV.

Imagine the darkness.
Imagine the light.

45

KENT MONKMAN

Séance

Sponsored by: Partners in Art

On the evening of October 19, 2007, artist Kent Monkman took on the guise of his alter ego, Miss Chief Eagle Testickle, and resuscitated his muses in a performance entitled *Séance*. Before a standing-room-only audience in the Hyacinth Gloria Chen Crystal Court, the main lobby at the Royal Ontario Museum, Monkman—in full regalia and employing so many costume changes that even the performer Cher herself would be envious—called painters Eugène Delacroix, Paul Kane and George Catlin back to life to have a "civilized discussion" about their art.

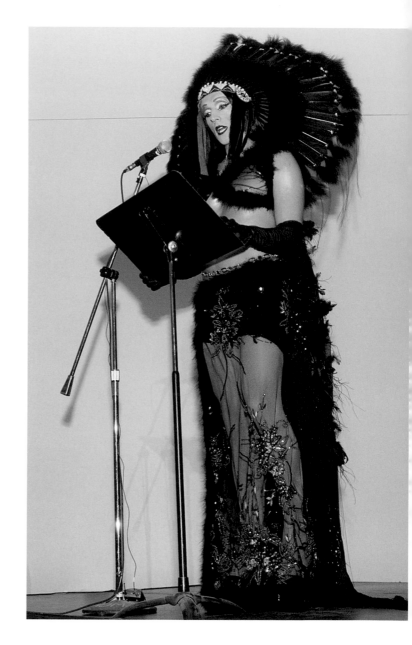

Shapeshifters, Time Travellers and Storytellers

Below are excerpts from Monkman's performance:

Music cue: Opening "Una vela! Una vela!" from Otello, by Giuseppe Verdi, 1887. (Miss Chief enters in black costume, wearing a small black headdress.)

Good evening, ladies and gentlemen. My name is Miss Chief Eagle Testickle. I am but a simple and humble painter.

Tonight, in place of my immensely popular lecture "The Customs and Manners of the European Male," I have decided to devote the evening to a discourse on painting, which will occur in the form of a séance.

They say that a great painter never dies. With that in mind, we should have very little difficulty summoning the spirits of my departed colleagues to this chamber.

I have a few questions prepared, and we will attempt to have conversations with three of them here tonight in the form of a casual Q & A.

My first guest is one of the greatest painters of all time, the incredible, inimitable Eugène Delacroix. Delacroix was the most important of the French Romantic painters, and it was his passionate brush stroke that influenced future generations of artists, such as the Impressionists.

It has, of course, been many years since I have seen Delacroix. While touring as a performer in Catlin's Gallery of the North American Indian, I had the greatest pleasure of modelling for him privately at his studio in Paris. He drew numerous sketches of me, both nude and in my full regalia. Later, he incorporated these studies into his famous painting *The Natchez*, as an ode to a "dying race."

Eugène Delacroix, *Astum pey yum'hah Okemow skew ...* come talk to Miss Chief.

Eugène, are you there, my dear?

ED: *Oui, Miss Chief. Je suis ici.*

MC: *Bon soir, mon cher.* It has been too long. I have missed you dearly, but seeing your great paintings always fills me with such joy.

[....]

MC: *Mon cher*, how do you go about choosing your subjects?

ED: I believe that when one needs a subject, it is best to hark back to the classics and choose something there. There are certain books that should never fail, also certain engravings. Dante, Lamartine, Byron, Michelangelo. Poetry is full of riches. I always remember certain passages from Byron. They are unfailing spurs to my imagination.

MC: Monsieur Delacroix, what are your thoughts on colour?

ED: Painters who are not colourists practise illumination, not painting. You must consider colour as one of the most essential factors, together with chiaroscuro, proportion and perspective.

MC: And how do you feel about pictorial licence?

ED: The most sublime effects of every master are often the result of pictorial licence. For example, the lack of finish in Rembrandt's work, the exaggeration in Rubens. Mediocre painters never have sufficient daring. They never get beyond themselves.

[....]

MC: Ah, yes, Nature! And what are your thoughts on Nature?

ED: It clearly matters very little to Nature whether man has a mind or not. The proper man is the savage. He is in tune with Nature as she really is.

MC: Oh, dear! Oh, please let's not speak of the noble savage. You know from our former talks in Paris that I find Rousseau tired and boring ... but you are my guest, so carry on without me briefly, if you must.

(Miss Chief exits.)

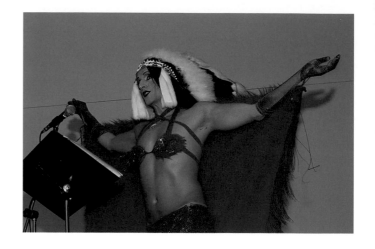

Music cue: Sunrise. "Daphnis prostrate at the grotto of the nymphs," from Daphnis et Chloé, *by Maurice Ravel, 1912. (Miss Chief re-enters in red costume, wearing a medium-sized headdress.)*

MC: Thanks so much, Mr. Delacroix, but we are running short of time, and I still have two more guests. Thanks for coming tonight. Bye-bye.

ED: Ah, OK, Miss Chief. *Encore la diva!*

MC: Ladies and gentlemen, the next painter I want to have a chat with is Paul Kane. During the years 1845 to 1848, Toronto artist Paul Kane undertook two journeys across Canada to paint landscapes and scenes of Native Indian life. Calling up Paul Kane should be relatively easy. I can

feel his chilly presence behind me here in the First Peoples gallery, where he resides as diligent sentinel over us First Nations.

Paul Kane, *Astum pey yum'hah Okemow skew* ... come talk to Miss Chief. Paul Kane, are you there, my dear?

PK: Hello, Miss Chief. I am here.

MC: Hello, Mr. Kane. Thanks for coming.

PK: So nice to see you, Miss Chief.

MC: Oh, really? I always felt that I was invisible to you—not authentic enough to be one of your models.

PK: The face of the red man is no longer seen. All traces of his footsteps are fast being obliterated from his once favourite haunts, and those who would see the aborigines of this country in their original state or seek to study their native manners and customs must travel far through the pathless forest to find them.

MC: Oh, that's just not true. We're everywhere. We're right here and always have been. But we're getting off topic. Tonight, we are talking about painting. Paul Kane, how do you go about choosing your subjects?

PK: I determined to devote whatever talents and proficiency

I possess to the painting of a series of pictures illustrative of the North American Indians and scenery. The subject was one in which I held a deep interest since boyhood. But the face of the red man is no longer seen.

MC: Ah, yes, you did already mention that. What are your thoughts on the model?

PK: The principal object in my undertaking was to sketch pictures of the principal chiefs and their original costumes in order to illustrate their manners and customs and to represent the scenery of an almost unknown country. One of the steersmen of our brigade was named Paulet Paul. He was a half-breed and certainly one of the finest formed men I ever saw, and when naked, no painter could desire a finer model.

MC: Ooh, I'd like that voyageur to paddle my canoe sometime! Your work is purported to be authoritative in terms of its accurate representations of Aboriginal people. From your own "remarkably authentic" paintings, what would be some of your favourite scenes?

PK: The Indians have a great dance called the Medicine Mask Dance.

MC: Oh, this is the name of the painting you have on display in the ICC right now.

PK: In this dance, six or eight of the principal men of the

tribe, generally medicine men, adorn themselves with masks that have been cut out of soft light wood, then highly painted and ornamented with feathers. The eyes and mouth are ingeniously made to open and shut. In their hands, the men hold carved rattles, which are shaken in time to a monotonous song or humming noise, for there are no words to it, that is sung by the whole company as they slowly dance round and round in a circle.

[....]

MC: Oh, this is really great stuff, Mr. Kane ... all right, I'm sure the audience would be thrilled to hear more of your true stories, but I need a drink.

(Miss Chief exits.)

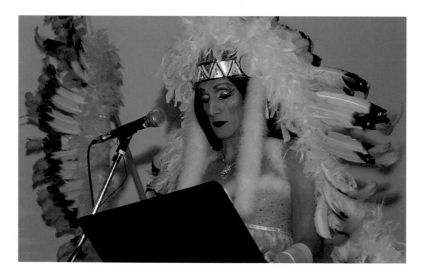

Music cue: Symphony No. 4, third movement, by Gustav Mahler, 1901. (Miss Chief re-enters in pink costume, wearing a huge pink and white headdress.)

MC: Thank you, Paul Kane, for your fascinating insights into the world of painting.

PK: It was my pleasure, and please stop by when you are in the neighbourhood so that I may create your likeness.

MC: Yeah, sure. Moving right along ... Our final guest this evening is none other than George Catlin, a 19th-century painter who spent eight years living with various tribes of North American Indians.

George Catlin, *Astum pey yum'hah Okemow skew* ... come talk to Miss Chief.

George, are you there, my darling?

GC: Hello, Miss Chief. I am here.

MC: Hello, Mr. Catlin. Thanks for coming.

GC: I must say that your appearance and beautiful regalia are reminiscent of the personage known and countenanced in every tribe as Indian "beau" or "dandy."

MC: Oh, really? How so?

GC: Such personages may be seen on every pleasant day, strutting and parading around the villages in the most beautiful and unsoiled dresses. They plume themselves with swan's down and the quills of ducks, with braids and plaits of sweet-scented grass and other harmless and unmeaning ornaments, which have no other merit than they themselves have—that of looking pretty and ornamental.

MC: Ooh, these personages sound lovely. Tell us more, Mr. Catlin.

GC: These clean and elegant gentlemen are denominated "faint hearts" or "old women" by the whole tribe. They seem to be tolerably well contented with the appellation, together with the celebrity they have acquired amongst the women and children for the beauty and elegance of their personal appearance.

MC: Sounds perfectly civilized—and decidedly less dreary than Mr. Kane's "true" stories. Now, Mr. Catlin, I understand that you have travelled quite extensively through North America, painting not only Indians and scenery but also the wild animals of North America, such as the buffalo.

GC: And what a splendid contemplation, when one imagines the buffalo as they might be seen in the future, preserved in their pristine beauty and wildness in a magnificent park, where the world could see them for ages to come—the Native Indian in his classic attire, galloping his wild horse, with sinewy bow and shield and lance, amid the fleeting herds of elks and buffaloes. What a beautiful and thrilling specimen for America to preserve and hold up to the view of her refined citizens and the world in future ages! A Nation's Park, containing man and beast, in all the wild freshness of Nature's beauty!

MC: Oh, there's a brilliant idea! Do you mean like a Jurassic Park for Indians?

GC: I would ask no other monument to my memory, nor any other enrolment of my name amongst the famous dead, than the reputation of having been the founder of such an institution.

MC: Um, well, Mr. Catlin, we'll let that go for a moment. I wanted to ask you about one specific painting, *Dance to the Berdashe*. Could you talk a little about this?

GC: *Dance to the Berdashe* depicts a very funny and amusing scene, which happens once a year or oftener, as they choose, when a feast is given to the *berdashe*, as he is called in French, or *I-coo-coo-a*, in the Sac and Fox language, who is a man dressed in women's clothes, as he is known to be all his life, and for extraordinary privileges which he is known to possess, he is driven to the most servile and degrading duties, which he is not allowed to escape. And he, being the only one of the tribe submitting to this disgraceful degradation, is looked upon as medicine and sacred, and a feast is given to him annually.

MC: Oh, could you elaborate on this disgraceful degradation and the servile duties?

GC: This is one of the most unaccountable and disgusting customs that I have ever met with in Indian country and, so far as I have been able to learn, belongs to only the Sioux and the Sac and Fox. Perhaps it is practised by other tribes, but I did not meet with it. And for further account of it, I am constrained to refer the audience to the country where it is practised and where I should wish that it might be extinguished before it be more fully recorded.

MC: Oh, dear. Mr. Catlin, you are a man of curious contradictions, but this is why I find you somewhat interesting. How sad that you have failed in your lofty aspirations to be the founder of a magnificent park where the refined citizens of the world might observe the Native Indian in his classic attire, galloping his horse among fleeting herds of elks and buffalo. For this, you may have to visit Germany. However, us beaux, dandies and faint hearts are still here.

You have now also failed to extinguish the Dance to the Berdashe, as we're about to bring it back, more unaccountable and disgusting than ever. Mr. Catlin, you may now return from whence you came, or you may stay and join in, because it's time to Dance to Miss Chief. It's time! It's time!

Music cue: "Dance to Miss Chief," by Byron Wong, 2007, with vocals by Shakura S'Aida, Damon D'Oliveira and Gail Maurice. (Three dancers enter the ring in front of the stage and begin dancing to Miss Chief. Audience joins the dance.)

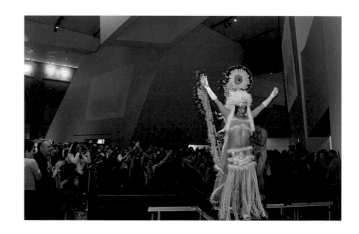

BIOGRAPHIES

CURATORS

Candice Hopkins is the Director/Curator of the Exhibitions Programme at the Western Front in Vancouver, where she recently curated exhibitions on the themes of architecture and disaster, and time and obsolescence (with Jonathan Middleton). She has an MA from the Center for Curatorial Studies at Bard College, New York, where she received the 2004 Ramapo Curatorial Prize for the exhibition *Every Stone Tells a Story: The Performance Work of David Hammons and Jimmie Durham*. Her writing has appeared in the edited publications *Transference, Tradition, Technology: Native New Media Exploring Visual & Digital Culture; Campsites;* and *Making a Noise! Aboriginal Perspectives on Art, Art History, Critical Writing and Community*. Hopkins is of Tlingit heritage.

Kerry Swanson has worked in many different capacities with the imagineNATIVE Film + Media Arts Festival in Toronto since 2004, serving as a member of the festival programming team and as Executive Director in 2007. In 2005, Swanson took responsibility for the festival's installations component, developing partnerships with such local galleries as the Museum of Contemporary Canadian Art (MOCCA), A Space Gallery and Trinity Square Video. An active member of the Toronto arts community, Swanson sat on the Board of Directors of the Liaison of Independent Filmmakers of Toronto (LIFT) from 2005 to 2007. She has a BA (Honours) in English literature from Queen's University and a graduate diploma in journalism from the London School of Journalism (U.K.). Currently, she is completing an MA in Communication and Culture at Ryerson University. Swanson is a member of the Michipicoten First Nation in northern Ontario.

ARTISTS

Suvinai Ashoona (1961–)

Suvinai Ashoona was born in Cape Dorset, Nunavut, where she continues to work today. Her parents, Kiuga Ashoona and Sorosilutu, are both accomplished artists who have been recognized for their significant contributions to the arts in Cape Dorset. Ashoona began drawing in 1995, creating a series of detailed pen drawings that demonstrates a unique sensibility for the region's landscapes. Composed of thousands of strokes, Ashoona's topographical drawings incorporate unexpected perspectives, with objects seen from both the ground and high above. Her intensely worked images range from closely observed naturalism to visions of the fantastical and strange. Throughout her work, Ashoona illustrates an Inuit understanding of the land, where proportions exist in relation to daily life.

In 1997, the Cape Dorset annual print collection included two of Ashoona's drawings, small dry-points titled *Interior* (1997–33) and *Settlement* (1997–34). Two years later, in its major exhibition *Three Women, Three Generations*, the McMichael Canadian Art Collection featured Ashoona's work alongside that of her aunt Napachie Pootoogook and her grandmother Pitseolak Ashoona. The Cape Dorset annual print collection of 2003 presented a remarkable series of prints by Ashoona that depicted scenes from her youth. In 2008, she took part in the group show *Cape Dorset Art: Tradition and Innovation, Arctic Art from the Albrecht Collection* at the Heard Museum North, in Scottsdale, Arizona. Ashoona continues to be a prolific graphic artist, working out of the Kinngait Studios in Cape Dorset.

Faye HeavyShield (1953–)

Born on the Blood Reserve near Stand Off in southern Alberta, Faye HeavyShield is a member of the Kainai (Blood) Nation. Her multidisciplinary artwork, which sometimes includes literal and metaphorical references to blood, is driven and inspired by her personal memories, her family and her community. Although HeavyShield's religious upbringing was Roman Catholic, her education included traditional Native stories. At the age of seventeen, she attended a residential school some forty miles from her home, an ordeal she has since explored in her art.

HeavyShield studied at the Alberta College of Art + Design and the University of Calgary, where she received a BFA in 1986. At college, HeavyShield began to focus on her identity as a Native woman, referencing her family history and life experiences in sculptural works. Combining personal narratives with materials such as bone, grass and wood, HeavyShield's art evokes raw strength, anger and determination. Not wanting to manipulate or decorate her past, HeavyShield voices her memories with simple, unadorned elements—she is unwilling "to dress a memory, because that would just weigh it down" (from *Bone Things: The Art of Faye HeavyShield*, 1992).

Over the past two decades, HeavyShield has attracted much recognition through numerous solo and group exhibitions across Canada and the United States. These include *Land, Spirit, Power*, National Gallery of Canada (1992); *New Territories*, Vision Planétaire, Montreal (1992); *She: A Roomful of Women*, Thunder Bay Art Gallery (1994); *Nations in Urban Landscapes*, Contemporary Art Gallery, Vancouver (1995); *Spiral and Other Parts of the Body*, La Centrale Galerie Powerhouse, Montreal (1997); and *Body of Land*, Kelowna Art Gallery (2002). HeavyShield's work is held in public and private collections throughout North America, including the National Gallery of Canada and the Heard Museum in Phoenix, Arizona. She lives and works in Lethbridge, Alberta.

Igloolik Isuma Productions

Co-founded in 1988 by Norman Cohn, Zacharias Kunuk, Pauloosie Qulitalik and Paul Apak Angilirq, Igloolik Isuma Productions, Inc., is Canada's first Inuit-owned independent film production company. Cohn and Kunuk, along with elder Qulitalik and Apak, developed Isuma's signature style of "re-lived" cultural drama, combining the authenticity of modern video with the ancient art of Inuit storytelling. Isuma's singular voice has garnered worldwide critical recognition, as well as numerous Canadian and international awards. Below are the biographies of its principals.

Norman Cohn (1946–)

Born in New York City, Norman Cohn moved to Canada in the 1970s and has lived in Igloolik and Montreal since 1985. His early work as a videographer was the subject of a solo exhibition in 1983, *Norman Cohn: Portraits*, which opened at the Art Gallery of Ontario, the Vancouver Art Gallery, the National Gallery of Canada and several other Canadian museums. In his early video work, he focused on marginal communities and studies of children, then moved on to collaborative quasi-documentary visual narratives. Cohn's experimental non-fiction film, *Quartet for Deafblind* (1987), was featured in *Documenta 8* (1987), in Kassel, Germany.

Cohn won a Guggenheim Fellowship in 1990 and numerous Canada Council awards, and he and Kunuk shared the 1994 Bell Canada Award for Outstanding Achievement in Video Art. In 1999, Cohn acted as co-producer and director of photography for Canada's first Aboriginal-language feature film, *Atanarjuat* (*The Fast Runner*, 2000). The highly acclaimed film won the Caméra d'or for Best Film Debut at the 2001 Cannes International Film Festival, as well as six Canadian Genie Awards. Cohn again acted as director of photography for the Isuma Productions feature film *The Journals of Knud Rasmussen* (2006), which he co-wrote and co-directed with Zacharias Kunuk. The film was selected to open the 2006 Toronto International Film Festival.

Zacharias Kunuk (1957–)

Born in Kapuivik (near Igloolik), Nunavut, Zacharias Kunuk lives and works in Igloolik. Throughout his youth, Kunuk watched his father and friends return from hunting trips and listened as they recounted stories of the hunt. "What I wanted to do," he says, "was go hunting with my father and videotape it. I wanted to see it and show it." In 1981, Kunuk sold three soapstone sculptures in Montreal so that he could buy a home-video camera, which he then began using to represent and preserve Inuit culture, stories and beliefs. He finds that the Inuit oral tradition translates naturally into the medium of film, allowing him to record his culture for future generations.

Kunuk's credits include the short dramas *Qaggiq* (*Gathering Place*, 1989), *Nunaqpa* (*Going Inland*, 1991) and *Saputi* (*Fish Traps*, 1993) and the documentaries *Nipi* (*Voice*, 1999), *Nanugiurutiga* (*My First Polar Bear*, 2001) and *Kunuk Family Reunion* (2004). He directed the thirteen-part television series *Nunavut* (*Our Land*, 1994–1995), which was broadcast on Bravo! and exhibited at *Documenta 11* in 2002. Kunuk won the Caméra d'or for Best Film Debut at the 2001 Cannes International Film Festival for the film *Atanarjuat* (*The Fast Runner*, 2000), which he directed and co-produced with

Norman Cohn. Recent documentary projects by Kunuk and Cohn include *Kiviaq Versus Canada* (2006) and *Exile* (2008). In 2001, Kunuk received the National Arts Award and the National Aboriginal Achievement Award. In 2005, he was named to the Order of Canada.

Pauloosie Qulitalik (1939–)

Born in Baffin Island, Pauloosie Qulitalik grew up in the traditional Inuit way of life. In his twenties, he relocated to the newly built settlement of Igloolik, where he continues to live and work. Qulitalik is Canada's first unilingual (Inuktitut) Inuk filmmaker, working as a producer for the Inuit Broadcasting Corporation from 1990 to 1992. He received a landmark Canada Council Video Production Grant in 1992 to produce the Isuma Productions film *Saputi* (*Fish Traps*, 1993).

As co-writer of the series *Nunavut* (*Our Land*, 1994–1995), Qulitalik drew on the memories of his youth to provide the core stories for this production. He has played major acting roles in every Isuma project, including *Kabloonak* (1995) and *The Journals of Knud Rasmussen* (2006), and his knowledge provides the authenticity of detail and point of view that render these works unique. He portrays the shaman Paul Qulitalik, one of the lead roles in the award-winning film *Atanarjuat* (*The Fast Runner*, 2000), the first feature-length fiction film written, produced, directed and acted by Inuit in Canada. A respected elder, Qulitalik has served for many years as chairman of Igloolik's Community Education Committee; he is also an accomplished hunter and fisherman.

Paul Apak Angilirq (1954–1998)

Paul Apak Angilirq was born on the land near the present-day town of Igloolik. He began his career in 1978 as a trainee in Canada's Inukshuk Project, the first initiative to train Indigenous television producers in remote Aboriginal communities. Apak joined the Inuit Broadcasting Corporation (IBC) when it was founded in 1981; he was honoured with a Special Recognition Award for his career contribution to the IBC in 1992, when he left to become vice-president of Isuma Productions. An experienced adventurer, Apak filmed *The Qidlarsuaaq Expedition*, retracing a 19th-century migration by dogteam from Igloolik to northern Greenland. In the documentary *Through Eskimo Country*, Apak recorded a voyage from Siberia to Alaska through the Bering Strait by walrus-hide boat. Drawing on extensive interviews with local elders, he also wrote the story and the Inuktitut screenplay for the award-winning film *Atanarjuat* (*The Fast Runner*, 2000). Apak passed away from cancer in December 1998 before the film was completed.

Brian Jungen (1970–)

Brian Jungen was born in Fort St. John, British Columbia, and he now lives and works in Vancouver. In his art, Jungen proposes a dialogue between his First Nations ancestry and the global economy by recrafting prefabricated commodities into sculptural objects. His work draws upon the tradition of "found art" espoused by such 20th-century artists as Andy Warhol and Marcel Duchamp. Jungen's series of Northwest Coast-style First Nations masks, stitched together from disassembled Nike Air Jordan sports shoes (from the *Prototype for New Understanding* series), critiques both consumer culture and ethnographic display. By critically manipulating and reappraising familiar consumer goods, Jungen produces startling and insightful works that connect the social and environmental effects of globalized mass production to the status and power these objects selectively transmit.

Since graduating from the Emily Carr Institute of Art + Design in 1992, Jungen has exhibited nationally and internationally, with solo shows at the New Museum of Contemporary Art, New York City (2005); the Tate Modern, London (2006); the Vancouver Art Gallery (2006); the Museum Villa Stuck, Munich (2007); the Witte de With, Rotterdam (2007); and the Casey Kaplan Gallery, New York City (2008). Recent group exhibitions include the Museum van Hedendaagse Kunst, Antwerp (2005); the Reykjavik Arts Festival (2005), the Heard Museum, Phoenix (2006); Stazione Leopolda, Florence (2006); La Biennale de Lyon (2007), France; the Transmission Gallery, Glasgow (2007); and the Biennale of Sydney (2008), Australia. Jungen is scheduled for a 2009 group exhibition at the Los Angeles County Museum of Art. In 2002, Jungen was the recipient of the inaugural Sobey Art Award in recognition of his outstanding artistic achievement.

Cheryl L'Hirondelle (1958–)

Cheryl L'Hirondelle (aka Waynohtêw, Koprek) is an Alberta-born artist and musician of mixed ancestry (Métis-Cree-non-status/treaty, French, German, Polish). Her creative practice is an investigation of a Cree world view (*nêhiyawin*) in contemporary time and space. Since the early 1980s, L'Hirondelle has created, performed and presented work in a variety of artistic disciplines, including music, performance art, theatre, performance poetry, storytelling, installation and new media. In the early 1990s, she began a parallel career as an arts consultant and programmer, cultural strategist/activist and director/producer of both independent works and projects within national artist networks. L'Hirondelle has worked in the Canadian independent music industry, several educational institutions, First Nations bands, tribal councils and Canadian governmental funding agencies, at both the provincial and the federal levels.

Her performance work is featured in *Caught in the Act: An Anthology of Performance Art by Canadian Women* (2004), written by Âhâsiw Maskêgon-Iskwêw and edited by Tanya Mars and Johanna Householder. L'Hirondelle's 2001 performance activity and corresponding Web site, cistêmaw îyîniw ohci (which means "the tobacco being"), are also discussed in Candice Hopkins' essay in *Making a Noise! Aboriginal Perspectives on Art, Art History, Critical Writing and Community* (Banff Centre Press, 2006). In 2004, L'Hirondelle and Hopkins were the first Aboriginal artists from Canada to be invited to Dakar, Senegal, to present work at Dak'Art Lab, as part of the 6th Edition of the Biennale of Contemporary African Art. For her online net.art projects *treatycard*, *Horizon Zero17:TELL* and *wêpinâsowina*, L'Hirondelle was the recipient of the imagineNATIVE Best New Media Award in both 2005 and 2006 (www.ndnnrkey.net).

L'Hirondelle's work as a musician has also garnered her several nominations and awards. Most recently, she received the 2006 Award for Best Female Traditional Cultural Roots Album of the Year and the 2007 Award for Best Group from the Canadian Aboriginal Music Awards for *Fusion of Two Worlds*, the first CD from her Aboriginal Women's Ensemble, M'Girl. Currently, she is working on a solo recording project entitled *Giveaway* with Toronto-based singer/songwriter/producer Gregory Hoskins.

Alan Michelson (1953–)

Alan Michelson is a New York-based artist of Mohawk ancestry. Born in Buffalo, New York, and adopted by a Jewish family from western Massachusetts, Michelson studied at Columbia College in New York City and the School of the Museum of Fine Arts in Boston, where he emerged as a painter exploring his lost culture and identity.

A multimedia artist working in painting, film video and performance, Michelson has produced multilayered installations that engage North America's landscape and history. In his art, Michelson meticulously searches for the Indian lives that have been hidden from our view. Through a process of uncovering, identifying and interpreting the Indian reality missing from the historical record and the popular mind, Michelson goes about determining the causes of this absence. The artist does not depict Indians in his works; instead, he presents the viewer with the conundrum of confronting the "absent Indian." In *No York* (1997), Michelson mapped the absent Indian of New York State by isolating Indigenous place names on an old school map. In *Mespat* (2001) and *Twilight, Indian Point* (2003), the artist continued to focus on the City and State of New York, exploring his ongoing interest in history and origins.

Michelson's public art includes projects with REPOhistory and the Public Art Fund, as well as a solo commission from the U.S. General Services Administration Art in Architecture Program for the new port of entry at Massena, New York. His work has been exhibited in a variety of international venues, including the Whitney Museum of American Art and the New Museum of Contemporary Art, and he was recently featured in the *Atlas Americas* video exhibition, Rio de Janeiro, and in *Thoreau Reconsidered*, Wave Hill, New York City. His work is in the permanent collections of several institutions, including the National Gallery of Canada and the Smithsonian National Museum of the American Indian.

An artist and educator, Michelson has taught at the Rhode Island School of Design since 2001. He has received numerous awards, including a National Endowment for the Arts Visual Artists Fellowship and a New York Community Trust Visual Artist's Grant in 2004. His work was the subject of a feature article in the May 2007 issue of *Sculpture* magazine.

Kent Monkman (1965–)

Born in St. Marys, Ontario, Kent Monkman is Swampy Cree of mixed descent, including English and Irish, and is a member of the Fisher River Band of northern Manitoba. When he was young, Monkman lived on a number of northern Manitoba reserves, as his father travelled the region teaching Christianity to the Cree in their own language. As a result, Monkman's contact with the Cree language was filtered through Christianity in the form of hymns and sermons. His work is inspired by his Aboriginal heritage and often deals with the impact of Christianity on Indigenous people.

Although he now works in a variety of complementary media, including film, video, illustration, performance and installation, Monkman began his exploration of the arts as a painter. In his first series of paintings, *The Prayer Language*, Monkman builds on themes of sexual power relations and Christianity. In *The Moral Landscape*, his second series, he paints explicit portrayals of his version of a colonial past. Intervening in the tradition of 19th-century landscape painting, Monkman deploys ironic reversal to place his subjects in unexpected yet telling circumstances. Idealized versions of the North American western landscape become stage sets upon which Monkman, in his guise as Miss Chief Eagle Testickle, acts out homoerotic fantasies and devious role play. Monkman's imagery ultimately challenges the ethnographic accuracy attributed to the representations of "Indians" by painters such as John Mix Stanley, Paul Kane, Peter Rindisbacher and Cornelius Krieghoff. In 2004, Monkman received a Visiting Artist Fellowship from the National Museum of the American Indian Native Arts Program to research 19th-century North American painters who contributed to the paradigm of the "romantic savage."

Monkman has had solo exhibitions at the Monte Clark Gallery in Vancouver, the Art Gallery of Hamilton, the Walter Phillips Gallery in Banff and the Indian Art Centre in Ottawa. He has participated in various international group exhibitions, including *"We come in peace..." Histories of the Americas* (2004), Musée d'art contemporain de Montréal, and *The American West* (2005), Compton Verney, Warwickshire, U.K. Monkman has created site-specific performances at the McMichael Canadian Art Collection and at Compton Verney, making Super 8 film versions of the performances. His short film and video works have been screened at such venues as the Sundance Film Festival, the Berlin International Film Festival and the Toronto International Film Festival. His dance video, *A Nation Is Coming* (1996), won Best Experimental and Best Editing Awards at the 1997 Alberta Film and Television Awards, and his film *Blood River* (2000) won the Best Film Award at the 2000 ImagineNATIVE Film + Media Arts Festival in Toronto.

Monkman's work is represented in the collections of the National Gallery of Canada, Musée des beaux-arts de Montréal, Museum London, the MacKenzie Art Gallery, the Woodland Cultural Centre, the Indian Art Centre and the Canada Council Art Bank. In 2007, the Art Gallery of Hamilton mounted his solo exhibition, *The Triumph of Mischief*, which travelled to museums across Canada, including the Museum of Contemporary Canadian Art (MOCCA) and the Winnipeg Art Gallery.

Peter Morin (1977–)

Peter Morin is from the Crow Clan of the Tahltan Nation of Telegraph Creek, British Columbia. In his artist's statement, Morin emphasizes the importance of his Tahltan identity as foundational to his work: "I want my art to honour my home, to honour the stories, words and songs of my people ... In my art practice, I am making a return to that original self, my Tahltan self." Morin's art often focuses on themes of family and healing, bringing together reflections of land and community to help build a deeper understanding of the effects of colonialism.

As a practising visual and performance artist, Morin looks deeply into the process of decolonization through relationship building and the use of Indigenous language. In *Stop, Drop and Bingo*, a 2004 solo exhibition at Winnipeg's Urban Shaman Gallery, Morin explored the impact of historical narratives on the formation of First Nations identities. A trained painter, he presented entirely new works in textile and printmaking in *Futuristic Regalia* (2004), at the Grunt Gallery in Vancouver. In this two-person exhibition with Sonny Assu, Morin referenced everyday objects, such as traditional button blankets, to address issues of safety, cultural clothing and identification.

An independent curator, visual artist and writer, Morin has worked to support emerging Aboriginal artists and writers in the arts community for more than ten years. His visual works have been exhibited both nationally and internationally. Morin's recent work *Things that are left behind for Ravens* (2007) appeared at the ODD Gallery in Dawson City. For 2008–2009, Morin has been awarded an Aboriginal Curatorial Residency from the Canada Council for the Arts, in partnership with the Western Front. Morin currently lives and works in Victoria, British Columbia, and plans to attend the MFA program at the University of British Columbia, Okanagan.

Nadia Myre (1974–)

Born in Montreal, Quebec, Nadia Myre is an installation artist of mixed Algonquin ancestry whose work explores themes of desire, identity and language. In 1997, she became a registered member of the Kitigan Zibi Anishinabeg Band. Starting in 1999, with the help of more than 200 participants, she began an extensive project to sew beadwork over all fifty-six pages of the annotated Indian Act. According to Myre, "The Indian Act speaks of the realities of colonization—the effects of contact and its often-broken and untranslated contracts." Myre dedicated the work to her mother, to voice the pain and frustration her mother had experienced in the community effort to secure official First Nations status under the Indian Act. In 2004, Myre initiated *The Scar Project*, an ongoing "open lab" in which viewers participate by sewing their scars—real or imagined—onto stretched canvases, then proceed to write their individual "scar stories" on paper. To date, she has assembled a collection of over 350 canvases and accompanying texts.

Myre earned a BFA from the Emily Carr Institute of Art + Design in Vancouver in 1997 and an MFA from Concordia University in Montreal in 2002. Since then, she has had solo exhibitions at OBORO, Montreal; the Grunt Gallery, Vancouver; Art Mûr, Montreal; the Union Gallery, Kingston; the Third Space Gallery, Saint John; and the Urban Shaman Gallery, Winnipeg. She has also participated in national and international group exhibitions, including *Unfolding Territories* (2002), Flinders University and the University of Wollongong, Australia; *Path Breakers* (2003), Eiteljorg Museum, Indianapolis; *The American West* (2005), Compton Verney, Warwickshire, U.K.; *Fray* (2006), Textile Museum of Canada, Toronto; *In My Lifetime* (2007), Canadian Museum of Civilization, Gatineau; and *Remix: New Modernities in a Post-Indian World* (2007 and 2008), Heard Museum, Phoenix, and Smithsonian National Museum of the American Indian. Myre's work has been featured in magazines such as *ARTnews*, *Parachute*, *Canadian Art* and *C Magazine* and is found in the collections of the Musée national des beaux-arts du Québec, the Canadian Museum of Civilization, Loto-Québec, the Eiteljorg Museum, the National Aboriginal Achievement Foundation, the Woodland Cultural Centre, the Indian Art Centre and the Canada Council Art Bank.

ACKNOWLEDGEMENTS

FROM THE CURATORS

Candice Hopkins and Kerry Swanson would like to thank the following people for their assistance in making *Shapeshifters, Time Travellers and Storytellers* possible:

The artists in this exhibition, whose work we admire; the wonderful staff at the Institute for Contemporary Culture and the Royal Ontario Museum; in particular, Kelvin Browne, Christine Lockett, Francisco Alvarez, Jason French, David Sadler, Laura Comerford, Barb Rice, Steven Spencer, Glen Ellis, Carolyn Hatch, Trudy Nicks, Ken Lister, Arni Brownstone, Renee Tratch, Cidalia Braga Paul and John Rubino. We also extend our thanks to Mark Engstrom and William Thorsell for their generous support of this exhibition. Thank you to Marcia Crosby, Ed Chan, Chris Jones and Mark Soo for their ongoing support. We would like to acknowledge and thank Robert Houle, Gerald McMaster and Anette Larsson for their expertise, and Tracy C. Read and Susan Dickinson of Bookmakers Press for their editorial services.

We would also like to thank the staff and board of imagineNATIVE, including Jason Ryle, Gisele Gordon, Danis Goulet, Sage Paul, Kerry Potts, Megan Denos, Adam Garnet Jones, Denise Bolduc, Charlotte Engel, Kathleen Meek, Shane Smith and Jesse Wente.

FROM THE ARTISTS

Cheryl L'Hirondelle would like to thank Denise Bolduc; Wayne Booker; Ron, Johanna and Emma Berti; Joe Osawabine; Audrey Wemigwans and the De-ba-jeh-mu-jig Theatre Group; Darlene Naponse; Julian Cote; Esther Osche; Shirley Bear; Jared Miller; Joseph Naytowhow; Gregory Hoskins and family; Archer Pechawis; Harry Quan; Tyler Wade; Jasen Hamilton and Trew Audio; Janet and Billiana Panic; and the Pruden family.

Alan Michelson: I would like to acknowledge and thank the following individuals who assisted me in the production of *Of Light After Darkness*: Josh Davidow, Martina Decker, Gisele Gordon, Vanessa Reiser Shaw and Gary Spearin. I would also like to thank the curators and the dedicated staff of the Royal Ontario Museum.

Nadia Myre: I would like to thank Robert Houle for inviting me into the project, the fantastic curatorial duo of Candice Hopkins and Kerry Swanson, as well as Jason French, Susan Ventura, Barb Rice and the rest of the ROM support staff for making it happen. Much love to my friends and family for always knowing what to do.

Brian Jungen would like to thank Dwight Koss from the Vancouver Art Gallery for his assistance with the installation of *Cetology* (2002).

PHOTO CREDITS

All photos © Royal Ontario Museum 2008

Front cover: detail from Nadia Myre, *The Dreamers*, 2007 © CARCC 2008/Photo by Brian Boyle
Page 27: © Royal Ontario Museum 2008/Photo by Sheila Farragher

This book has been published in conjunction with the exhibition, *Shapeshifters, Time Travellers and Storytellers*, organized by the Institute for Contemporary Culture at the Royal Ontario Museum, on display between October 6, 2007, and February 28, 2008.
© 2008 Royal Ontario Museum

Royal Ontario Museum
100 Queen's Park
Toronto, Ontario M5S 2C6
www.rom.on.ca

Library and Archives Canada Cataloguing in Publication
Hopkins, Candice, 1977-
 Shapeshifters, time travellers and storytellers / Candice Hopkins
and Kerry Swanson.

ISBN 978-0-88854-455-1

 1. Indian art–Canada–Exhibitions. 2. Inuit art–Canada–Exhibitions.
3. Art, Modern–21st century–Exhibitions–Literary collections. I. Swanson,
Kerry, 1974- II. Royal Ontario Museum. Institute for Contemporary
Culture III. Title.

NX513.3.I5H66 2008 704.03'97 C2008-905175-0

Project Manager: Glen Ellis
Editors: Tracy C. Read, Susan Dickinson
Designers: Virginia Morin, Beatriz Alvarez
Photographer: Brian Boyle

Funds for this publication were generously provided by the Government of Canada through the Department of Canadian Heritage.

Printed and bound in Canada by Tri-Graphic Printing Ltd.

The Royal Ontario Musuem is an agency of the Ontario Ministry of Culture.